Martha's Vineyard
PERSPECTIVES

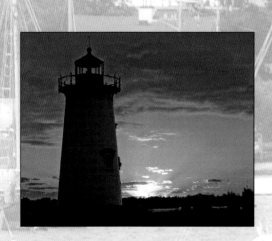

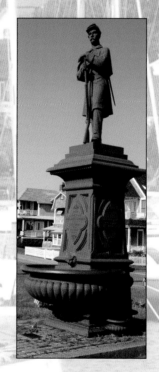

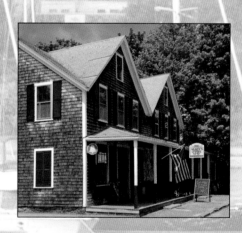

Arthur P. Richmond

Schiffer Publishing Ltd®

4880 Lower Valley Road, Atglen, Pennsylvania 19310

Contents

Other Schiffer Books By The Author:
Cape Cod Wide. ISBN: 9780764327766. $39.95
Cottages of Oak Bluffs: 20 Postcards. ISBN: 9780764326837. $9.95
Gingerbread Gems: Victorian Architecture of Oak Bluffs. ISBN: 9780764326820.
 $29.95
Harbors of Cape Cod & The Islands. ISBN: 9780764330070. $39.99
Lighthouses of Cape Cod & The Islands. ISBN: 0764324608. $14.95
Martha's Vineyard Wide. ISBN: 9780764335556. $45.00

Other Schiffer Books on Related Subjects:
Cape Cod and the Islands from Above. Spencer Kennard. ISBN: 9780764330438.
 $39.99
Cape Cod and the Islands: Where Beauty & History Meet. Kathryn Kleekamp. ISBN:
 9780764333170. $29.99
Cape Cod & the Islands: Reflections. Christopher Seufert. ISBN: 9780764334054.
 $24.99
Martha's Vineyard Houses and Gardens. Text by Polly Burroughs; Photography by Lisl
 Dennis. ISBN: 9780764327520. $39.95
Painted Ladies: Balusters & Columns. Robert and Lynn Gatchell. ISBN: 9780764330452.
 $29.99
Painted Ladies: Corbels & Gingerbread. Robert and Lynn Gatchell. ISBN: 9780764330469.
 $29.99

Designed by Mark David Bowyer
Type set in Lucian BT / Zurich BT

ISBN: 978-0-7643-3834-2
Printed in China

Schiffer Books are available at special discounts for bulk purchases for sales promotions or premiums. Special editions, including personalized covers, corporate imprints, and excerpts can be created in large quantities for special needs. For more information contact the publisher:

Published by Schiffer Publishing Ltd.
4880 Lower Valley Road
Atglen, PA 19310
Phone: (610) 593-1777; Fax: (610) 593-2002
E-mail: Info@schifferbooks.com

For the largest selection of fine reference books on this and related subjects, please visit our website at **www.schifferbooks.com**
We are always looking for people to write books on new and related subjects. If you have an idea for a book
please contact us at the above address.

This book may be purchased from the publisher.
Include $5.00 for shipping.
Please try your bookstore first.
You may write for a free catalog.

In Europe, Schiffer books are distributed by
Bushwood Books
6 Marksbury Ave.
Kew Gardens
Surrey TW9 4JF England
Phone: 44 (0) 20 8392 8585; Fax: 44 (0) 20 8392 9876
E-mail: info@bushwoodbooks.co.uk
Website: www.bushwoodbooks.co.uk

Introduction

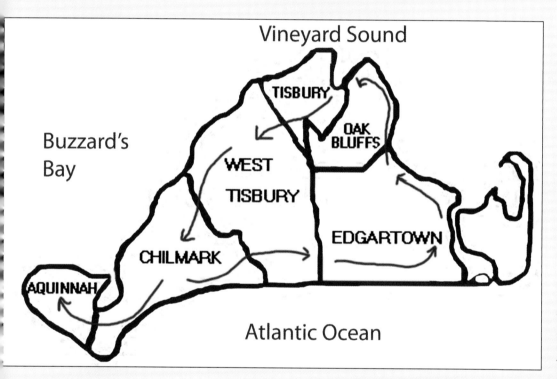

Vineyard Sound

Buzzard's
Bay

TISBURY

OAK
BLUFFS

WEST
TISBURY

EDGARTOWN

CHILMARK

AQUINNAH

Atlantic Ocean

Welcome to Martha's Vineyard (MV). Follow along as we take a tour of the island and visit not only the popular sites frequented by tourists, but also the hidden gems found off-the-beaten-path. Only seven miles from the mainland, the island can only be reached by boat or plane. With about 15,000 year-round residents, the island becomes a destination for the rich and famous in the summer. U.S. Presidents, celebrities, and other visitors are attracted by the miles of beaches, pristine natural areas, and a list of world class activities. Although, it may have been visited by Vikings more than a thousand years ago, the island was possibly named by Bartholomew Gosnold, who visited the area in 1602, in memory of his infant daughter Martha. Our photographic tour begins with a flight around the island. Upon landing, we begin our ground tour at Vineyard Haven, where those who arrive by sea debark from the ferry. After a brief visit in town, we head "up island" to Chilmark and Aquinnah. After a tour of Gay Head cliffs, at the southwest corner of the island, our journey takes us to the old whaling harbor of Edgartown. We then head to the Victorian village of Oak Bluffs and the Campmeeting Association Campground. Finally, we head back to Vineyard Haven riding along the side of the harbor. The arrows on the map show our route around the island. As you read through the book, refer back to the map to find your location and the setting where the image was captured.

The MV *Martha's Vineyard* is just one of several ferries that shuttle passengers and freight between the mainland and the island.

4

In one of these gravesites in this cemetery at the Cathedral in Bury St. Edmunds, England, Martha, the infant daughter of Bartholomew Gosnold, is buried. A plaque commemorates Gosnold, his voyage to Cape Cod in 1602, and the naming of the island in the memory of his daughter.

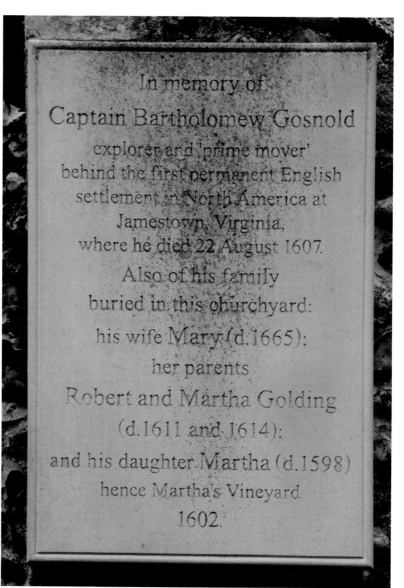

In memory of
Captain Bartholomew Gosnold
explorer and 'prime mover'
behind the first permanent English
settlement in North America at
Jamestown, Virginia,
where he died 22 August 1607.

Also of his family
buried in this churchyard:
his wife Mary (d.1665);
her parents
Robert and Martha Golding
(d.1611 and 1614);
and his daughter Martha (d.1598)
hence Martha's Vineyard
1602.

The ferry dock in Vineyard Haven is part of the town of Tisbury. A brief walk from the ferry dock leads to a busy intersection where you can head to any town on the island.

Near the ferry dock, it is possible to book a bus trip to explore the island.

An Aerial Tour of the

One of the best ways to see Martha's Vineyard is from the air. A airfield in Edgartown, it is possible to rent a single engine moder biplane. Both provide marvelous views of the island. Follow along the island in a little over an hour's time.

I took a ride on the red plane several years ago. The flight was amazing... we had a retired Eastern Airlines pilot who asked us if we wanted to make a loop in the air. My heart went to my feet but I loved it! K

There are several planes at the Katama Airfield that are available to rent for scenic flights. You have a choice of the classic Waco biplane or a modern Cessna.

Vineyard Haven Harbor is the busiest port on the island, with several docks, including the ferry pier at the top and a cruise ship tied up at the dock at the bottom of the image. The red vessel is the Nantucket Lightship WLV 612.

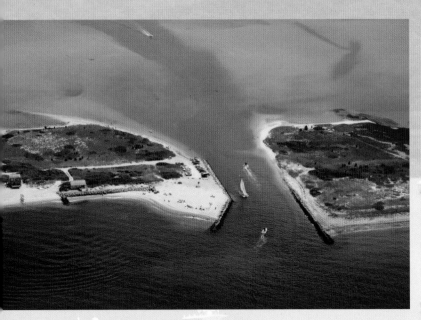

Along the western shore of the island
is the entrance to Tashmoo Pond.

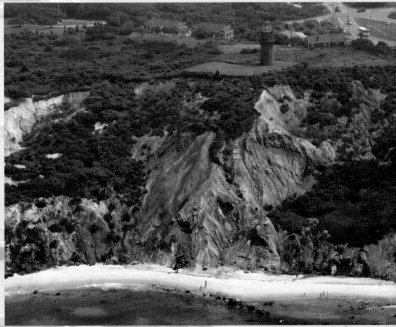

Near the southwest tip of the island, Gay Head Lighthouse sits
atop the distinctive and brightly colored clay cliffs.

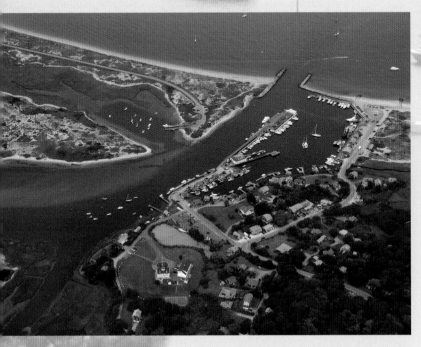

Menemsha Harbor provides
moorings and dockage for both
commercial and recreational craft.
The distinctive red-roofed Coast
Guard facilities are visible.

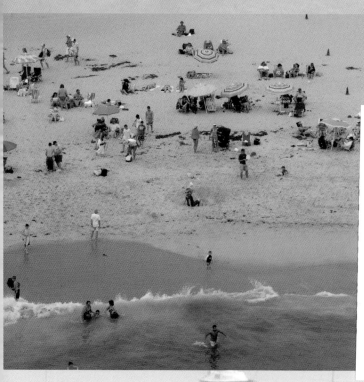

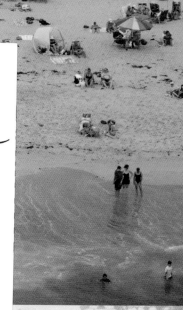

The dune is now connected again but you can't drive over this part because its too narrow + the sand too soft

↓

All along the south side of the island is a sandy beach that attracts summer visitors.

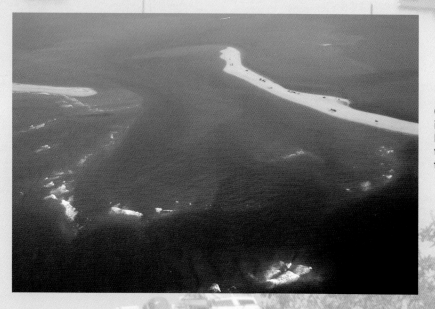

Once connected, this break in the dune along South Beach now opens the waters of Edgartown Harbor to the Atlantic Ocean.

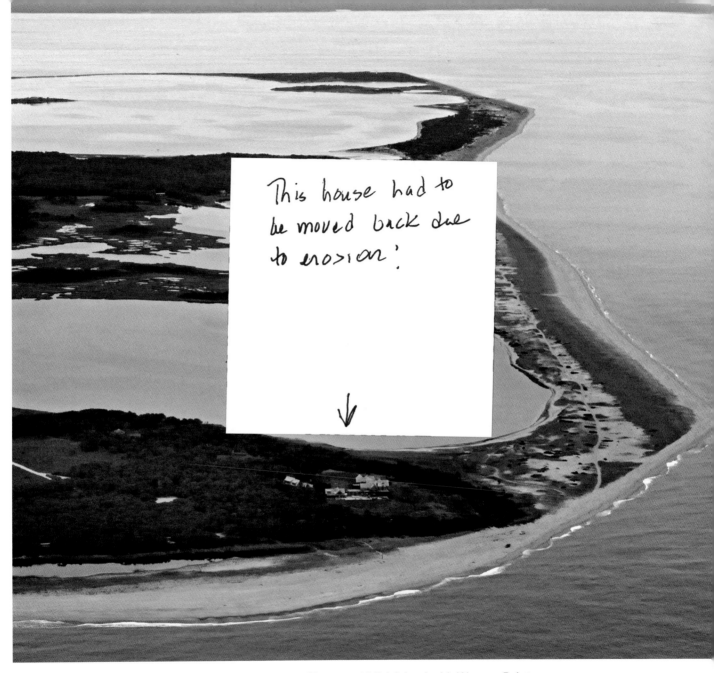

This view of the east coast of Martha's Vineyard shows Chappaquiddick Island with Wasque Point in the foreground and Cape Poge in the distance. Cape Cod is seen in the distant background.

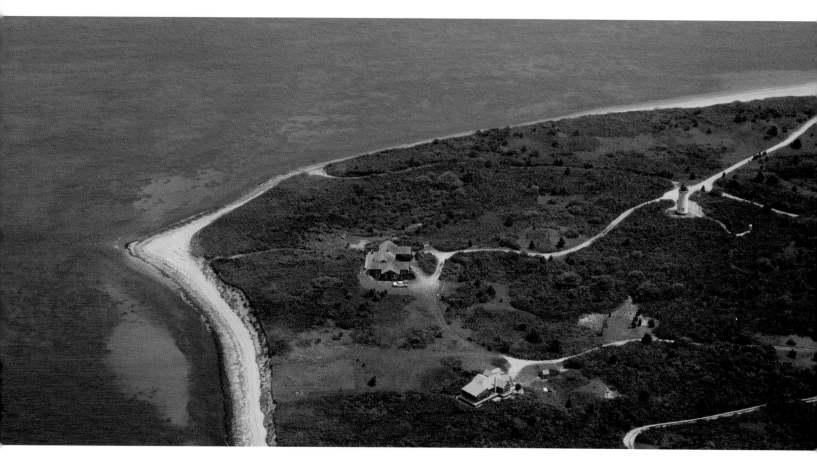

The northeast tip of the island has the distinctive Cape Poge Lighthouse, as well as several private residences.

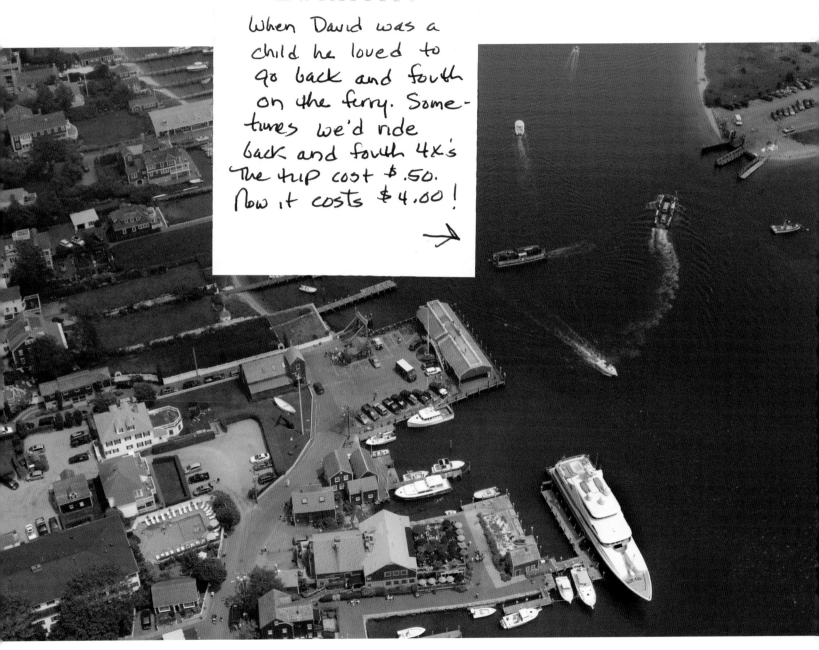

When David was a child he loved to go back and fourth on the ferry. Sometimes we'd ride back and fourth 4x's The trip cost $.50. Now it costs $4.00!

→

Edgartown Harbor with the "on time" ferry that links to Chappaquiddick Island.

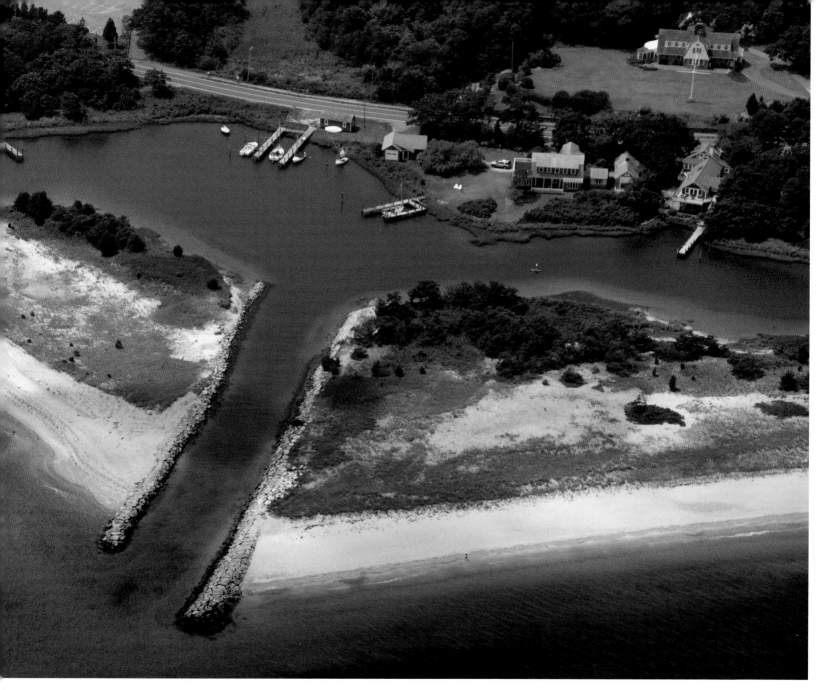

A quiet protected harbor along the north shore of the island.

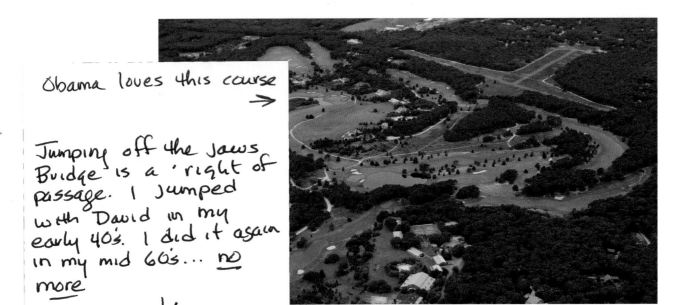

Obama loves this course →

Jumping off the Jaws Bridge is a 'right of passage'. I jumped with David in my early 40's. I did it again in my mid 60's... no more

↓

...s probably the most famous of the several courses on the island.

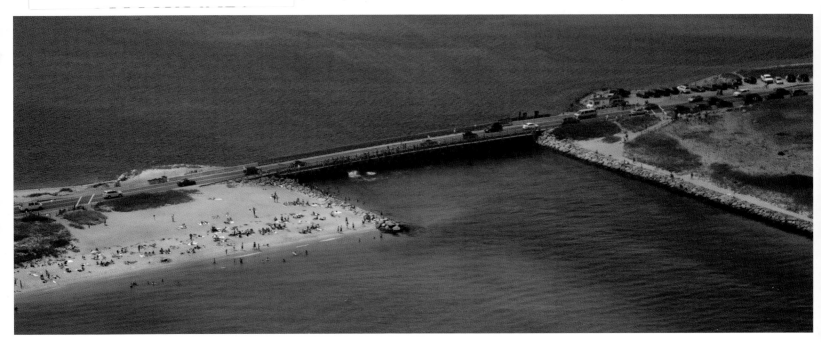

This bridge on Beach Road, which connects Edgartown with Oak Bluffs, was made famous in the movie, *Jaws.*

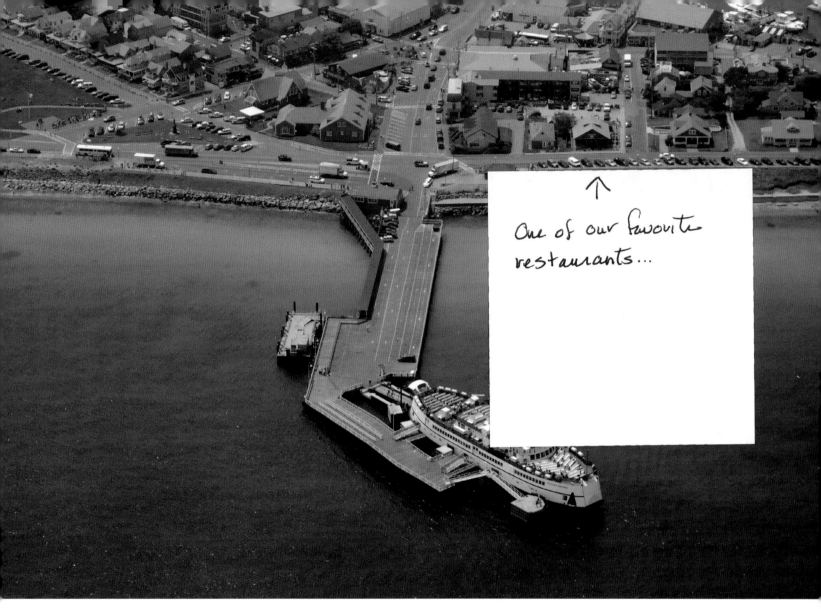

A ferry is docked at the pier in Oak Bluffs.

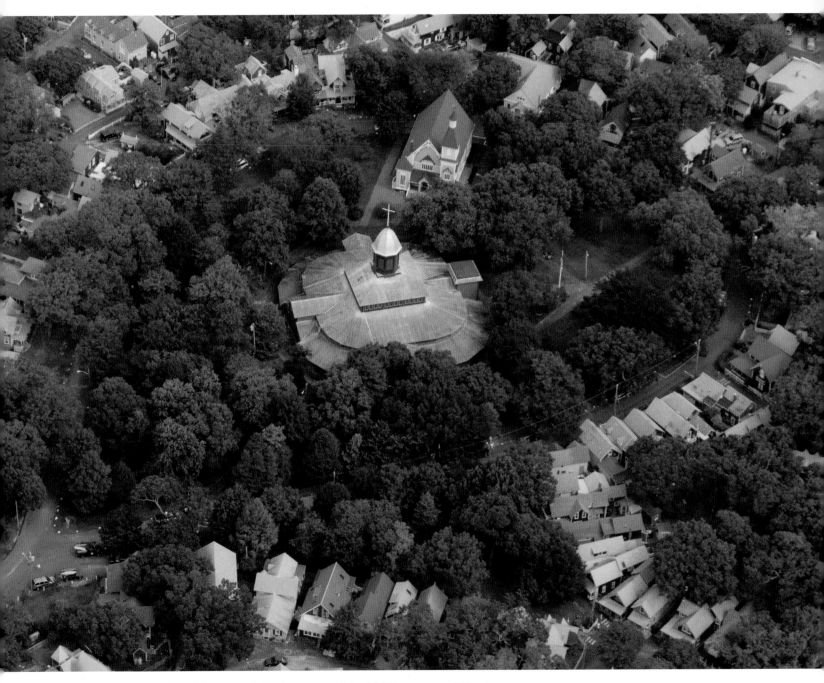

The Tabernacle, with the white cross, is in the center of the MV Campground Meeting.

Tisbury

Tisbury is one of the smallest towns on the island, but it is also one of the busiest and most active year round. While all the towns burst with summer visitors, the harbor at Vineyard Haven remains a daily focal point for all boat traffic coming from, or leaving for, the mainland. Originally [...] Holes Hole by the Pilgrims, Vineyard Haven is now synonymous with Tisbury. In- [...] t is now West Tisbury. In 1892, the town was split [...] with a wide variety of shops and restaurants open [...] o a wide range of tastes. Walk the streets beyond [...] includes Colonial, Federal, Victorian, and Greek [...] are the Town Hall and the cemetery behind it, the [...] e sights are within [...] t is the West Chop [...] arbor.

My Dad's Mom, our Nonnie, traveled to the Vineyard as a young adult in the late 1800's. The area to the left is where she stayed (in tents!) Today the tents are obviously gone + the Gingerbread Houses have replaced them.

The ferry from Woods Hole passes by the West Chop Lighthouse on its way to Vineyard Haven.

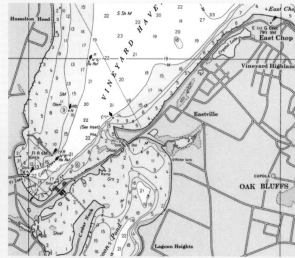

A chart of protected Vineyard Haven Harbor, which for centuries had included whaling ships, schooners, and a variety of other vessels. East Chop Lighthouse can be seen at the top right of the chart.

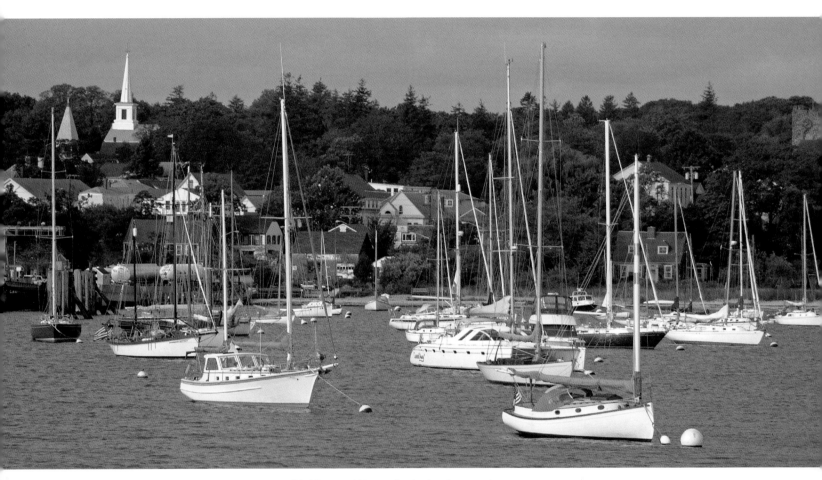

Recreational craft are moored in the harbor with Vineyard Haven in the background.

The lightship WLV 612 is seasonally anchored in the harbor. She was the last of two lightships "on station" at Nantucket Shoals.

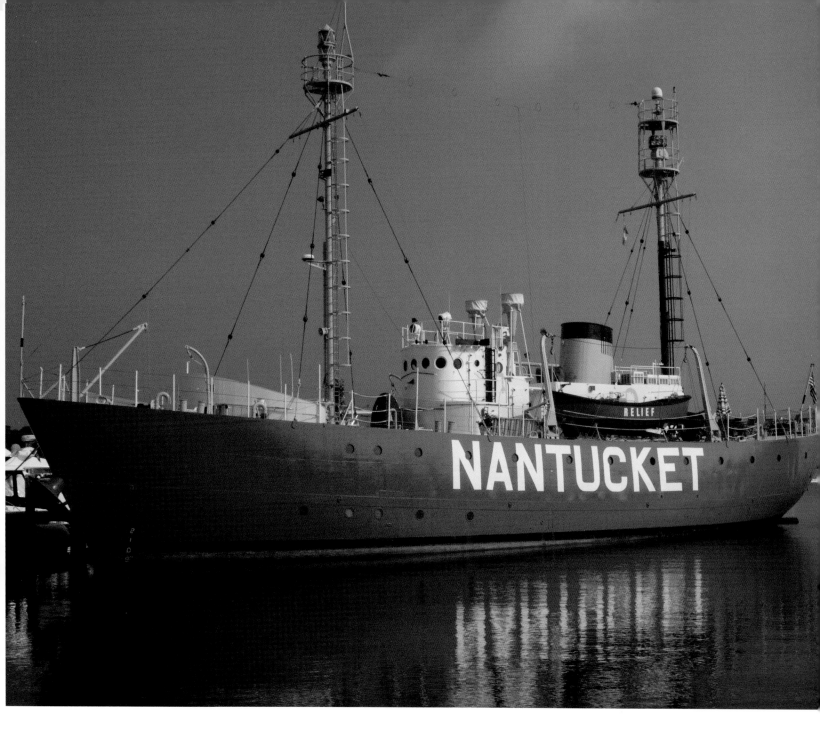

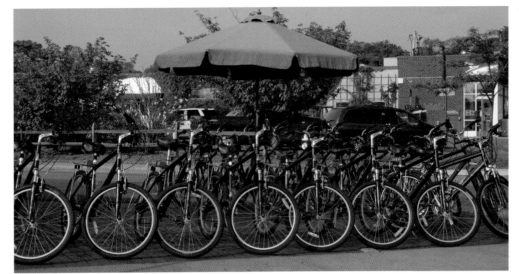

One of the best ways to see the Island is to rent a bicycle and follow the miles of well-maintained trails which have frequent directive and educational signboards.

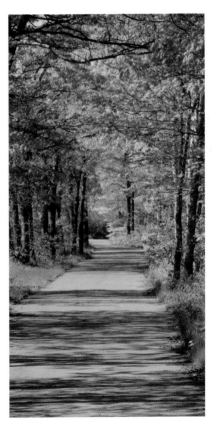

There's a little beach at Owen Park. It's one of our favorites as you can look at the boats + watch the ferry come and go!

↓

Just west of the ferry dock is William Barry Owen Park, which includes a bandstand for summer concerts, as well as a sandy beach on the harbor.

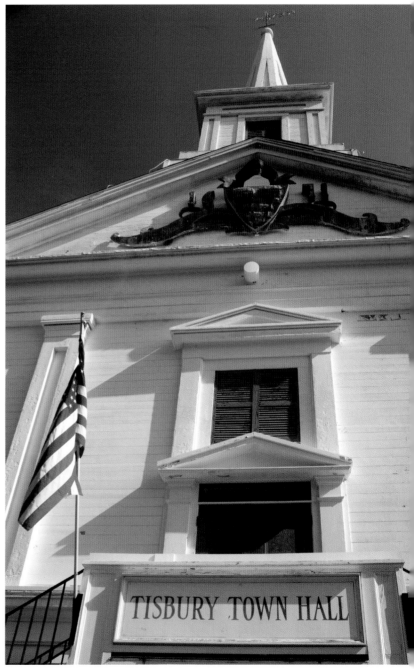

The Tisbury Town Hall, built about one hundred and fifty years ago, was originally a Congregational church and then later a Unitarian Church, before becoming the town hall.

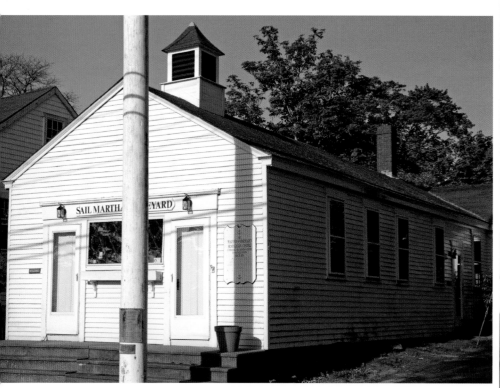

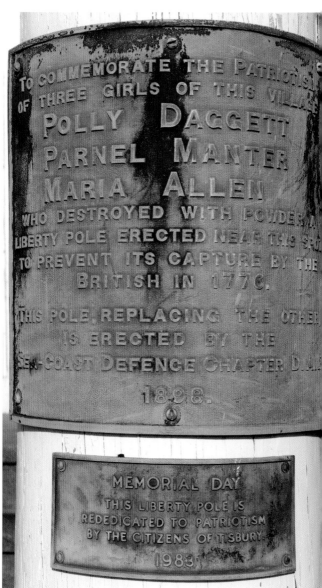

TO COMMEMORATE THE PATRIOTISM
OF THREE GIRLS OF THIS VILLAGE
POLLY DAGGETT
PARNEL MANTER
MARIA ALLEN
WHO DESTROYED WITH POWDER A
LIBERTY POLE ERECTED NEAR THIS SPOT
TO PREVENT ITS CAPTURE BY THE
BRITISH IN 1776.
THIS POLE, REPLACING THE OTHER
IS ERECTED BY THE
SEA-COAST DEFENCE CHAPTER D.A.R.
1898.

MEMORIAL DAY
THIS LIBERTY POLE IS
REDEDICATED TO PATRIOTISM
BY THE CITIZENS OF TISBURY.
1983

Built in the late 1800s, the Seaman's Bethel provided mariners with a reading room, game room, and a place for sailors to congregate to have a "social, moral, and well being" location. The liberty pole in the foreground has a history of its own, dating back to the Revolutionary War.

Beyond the ferry dock, well maintained homes of various architectural styles can be found.

Known for its distinctive clothing, Black Dog also includes a bakery, tavern, and sailing ships.

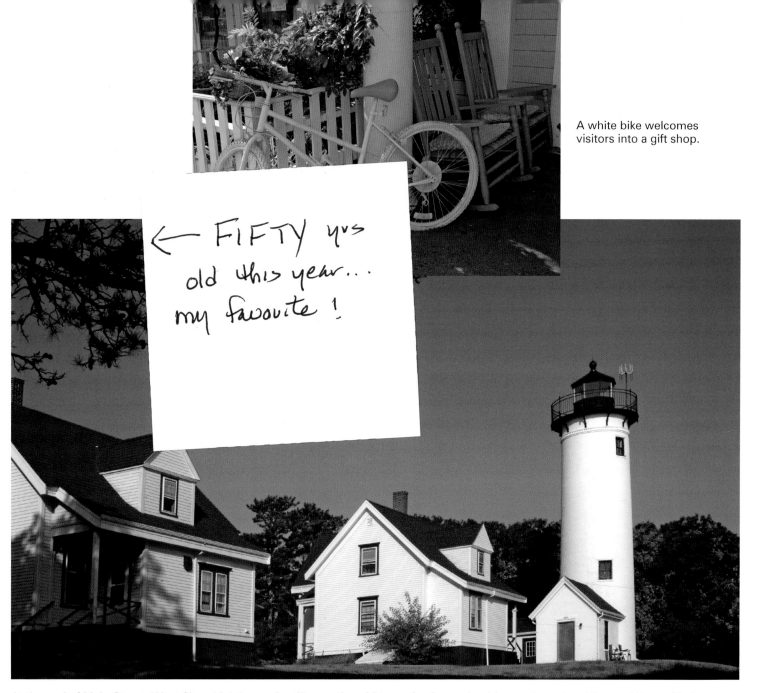

A white bike welcomes visitors into a gift shop.

← FIFTY yrs old this year... my favourite!

At the end of Main Street, West Chop Lighthouse is still an active aid to navigation and guides mariners into Vineyard Haven Harbor.

West Tisbury

First settled in the 1660s, this rural community has a population of fewer than three thousand permanent residents. In the summer season, the town attracts visitors who wish to experience its quiet, bucolic lifestyle. Part of what is considered "up island," which also includes the towns of Chilmark and Aquinnah, West Tisbury is the agricultural heartland of the island. Farmer's markets, agricultural fairs and events, and art festivals highlight the community activities. Farm stands with fresh flowers and vegetables are common during the season on many of the town's roads. Refuges, forests, ponds, and beaches are found throughout the town.

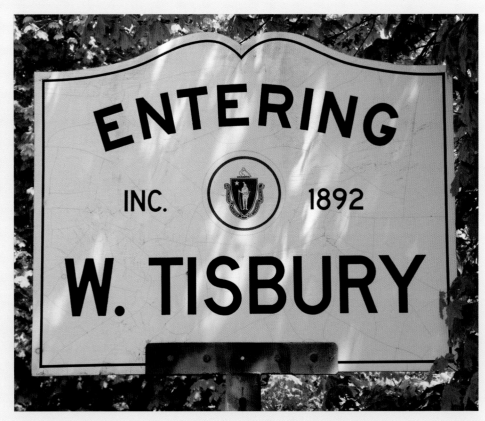

On the west side of Martha's Vineyard, Tashmoo Pond provides anchorage for commercial and recreational craft as well as shellfishing opportunities.

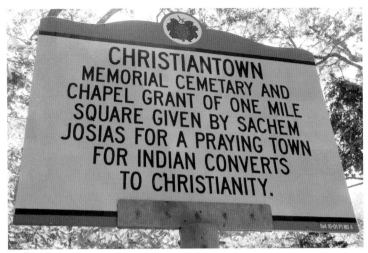

CHRISTIANTOWN
MEMORIAL CEMETARY AND
CHAPEL GRANT OF ONE MILE
SQUARE GIVEN BY SACHEM
JOSIAS FOR A PRAYING TOWN
FOR INDIAN CONVERTS
TO CHRISTIANITY.

Native American influences on the island can be found in each town. In West Tisbury, Christiantown, dating back hundreds of years, has a lengthy history and includes a chapel and a cemetery.

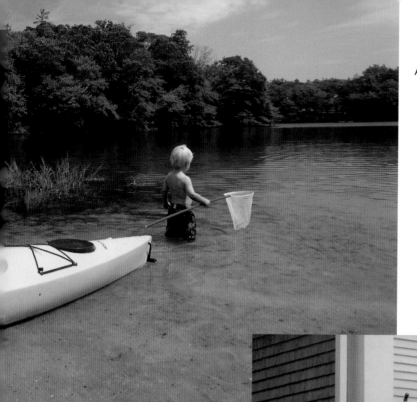

A young explorer searches Seth's Pond.

Gift shops and galleries can be found on many roads on the island.

Conservation of land and beaches will help to preserve Martha's Vineyard for future generations. The Cedar Tree Neck Sanctuary, with over 312 acres, includes forests, meadows, and beach.

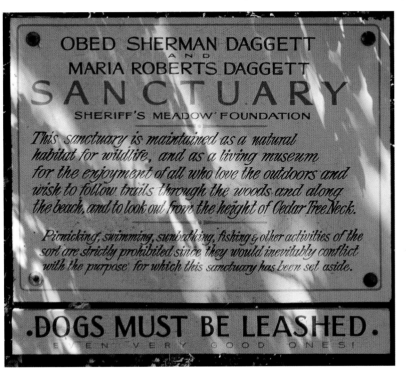

OBED SHERMAN DAGGETT
AND
MARIA ROBERTS DAGGETT
S A N C T U A R Y
SHERIFF'S MEADOW FOUNDATION

This sanctuary is maintained as a natural habitat for wildlife, and as a living museum for the enjoyment of all who love the outdoors and wish to follow trails through the woods and along the beach, and to look out from the height of Cedar Tree Neck.

Picnicking, swimming, sunbathing, fishing & other activities of the sort are strictly prohibited since they would inevitably conflict with the purpose for which this sanctuary has been set aside.

. DOGS MUST BE LEASHED .
EVEN VERY GOOD ONES!

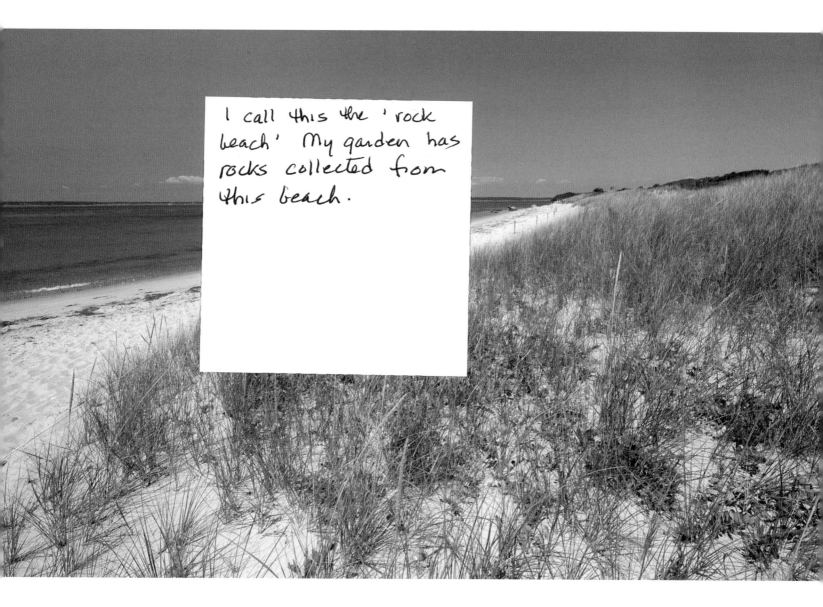

I call this the 'rock beach' My garden has rocks collected from this beach.

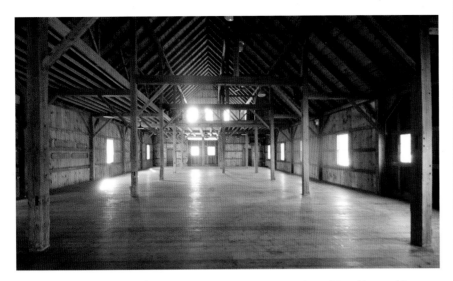

This one hundred year old barn, originally built in northern New Hampshire, dismantled, and then re-constructed in West Tisbury, is the spacious home of the MV Agricultural Society.

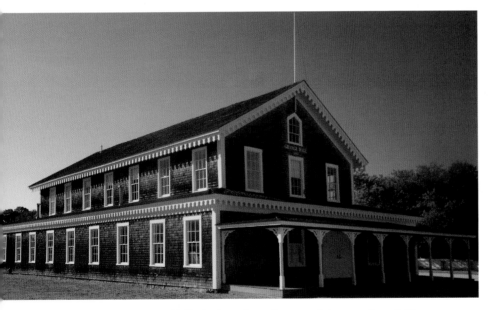

Nearby is the Grange Hall, the location of many of the town's activities, including the weekly farmer's market and Artisan Festival.

For centuries, Alley's store not only has provided a variety of goods, but has been a gathering place for the community.

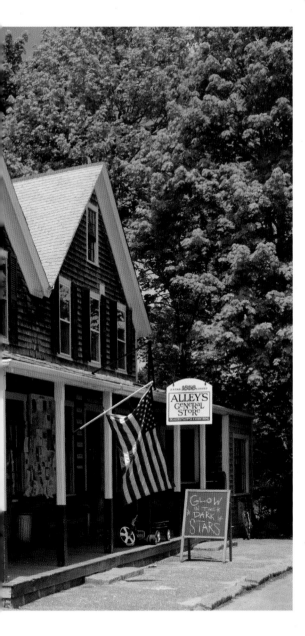

In the center of the town is the Congregational Church with its distinctive white steeple.

Alleys was an amazing store filled with every-thing you can imagine. It was sold last year and the new owners have ruined its charm... now a boring high end grocery store with a few gifts

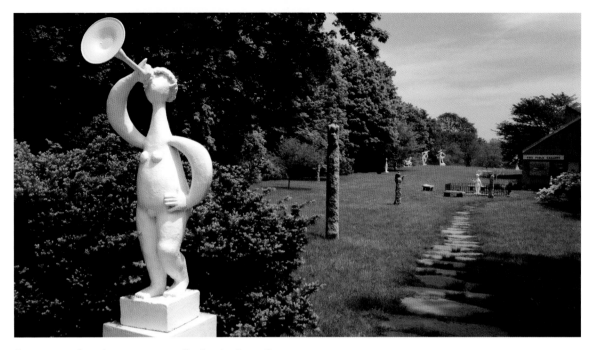

Statuary and sculptures are on display in the gallery.

With a piano in nearly every house, the street lived up to its name.

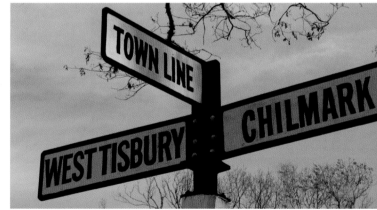

Chilmark

Another "up island town," Chilmark not only has fields, farms and forests, but is probably best known for its picturesque harbor of Menemsha. With less than a thousand year-round residents, the population in the summer swells, taking advantage of the harbor and beaches. Pastoral vistas, peaceful beaches, and rocking chair afternoons are an apt description of this community.

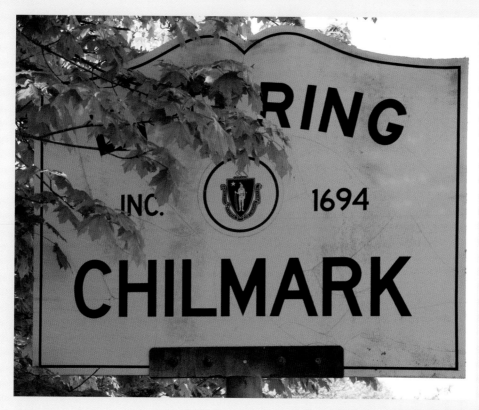

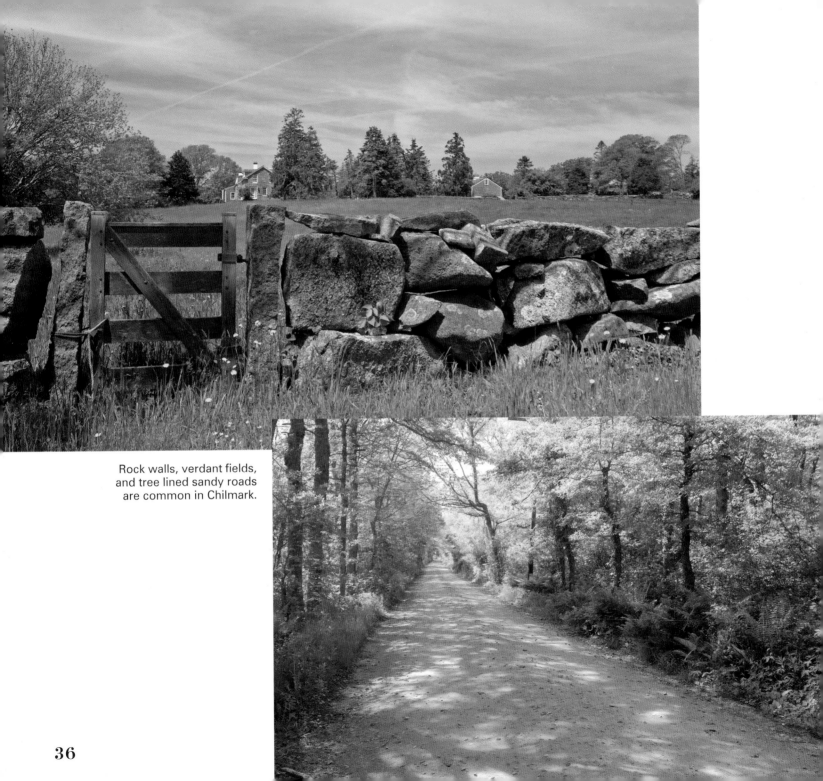

Rock walls, verdant fields, and tree lined sandy roads are common in Chilmark.

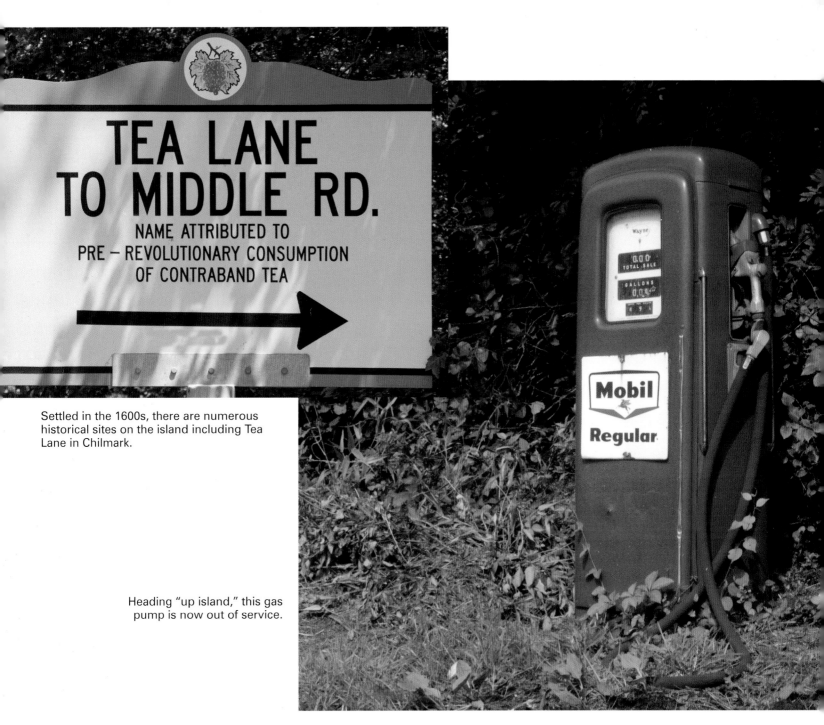

TEA LANE TO MIDDLE RD.
NAME ATTRIBUTED TO
PRE – REVOLUTIONARY CONSUMPTION
OF CONTRABAND TEA

Settled in the 1600s, there are numerous historical sites on the island including Tea Lane in Chilmark.

Heading "up island," this gas pump is now out of service.

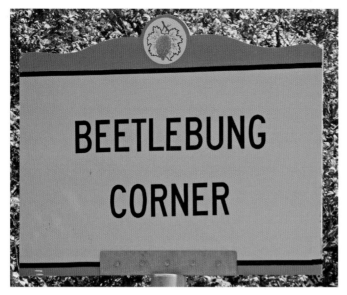

Chilmark town center is centered around Beetlebung Corner where several rural roads meet. The town hall, community church, post office, library, and other attractions can be found nearby. Named for a nearby stand of tupelo trees that were used in making parts of barrels, beetlebung was first coined as a word on MV.

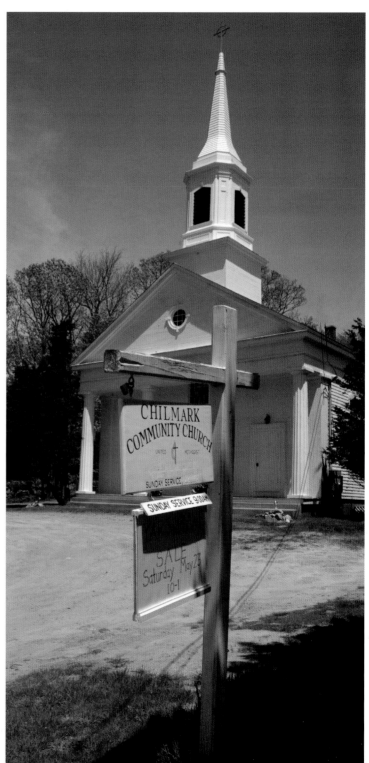

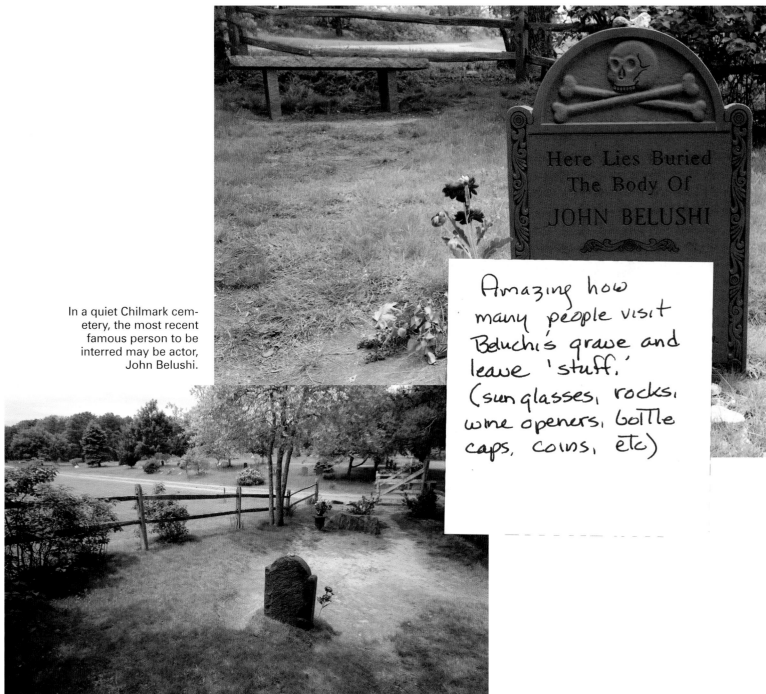

In a quiet Chilmark cemetery, the most recent famous person to be interred may be actor, John Belushi.

Here Lies Buried The Body Of JOHN BELUSHI

Amazing how many people visit Beluchi's grave and leave 'stuff.' (sunglasses, rocks, wine openers, bottle caps, coins, etc)

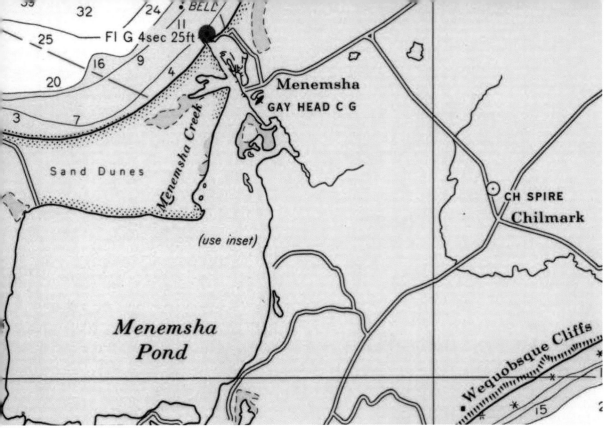

A navigational chart of Menemsha Harbor. Previously mentioned, Beetlebung Corner is the intersection identified as Chilmark. You can also identify the location of the community church.

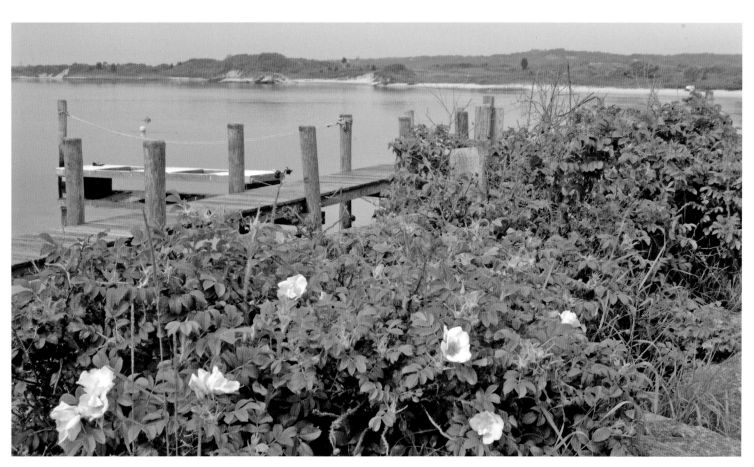

Beach roses bloom near a dock overlooking Menemsha Creek.

Mike loves Larsens... You can order a lobster (or whatever), take it to the beach and enjoy the sunset.

Several markets on Dutcher Dock, offer fres[...] [...]ed bass.

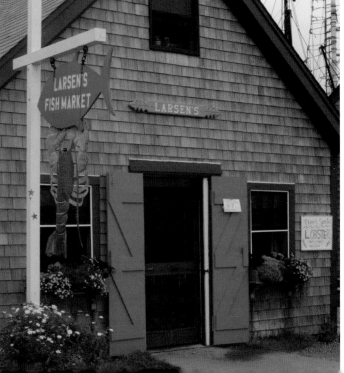

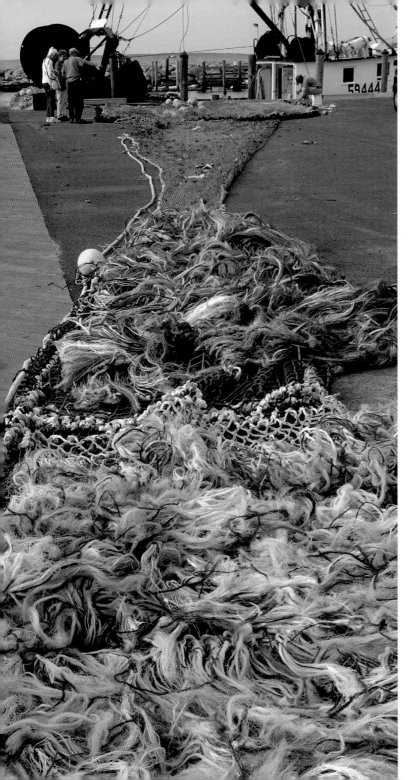

Fishing lures hang in the window of a shanty.

Nets, in need of repair, are
spread across the dock.

43

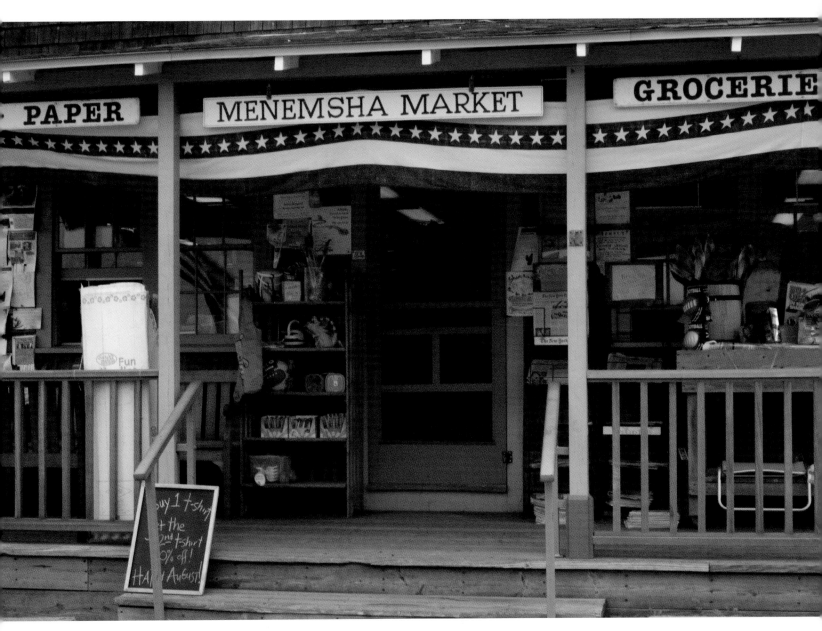

Menemsha market, only open during the summer season, is a quaint seaside store.

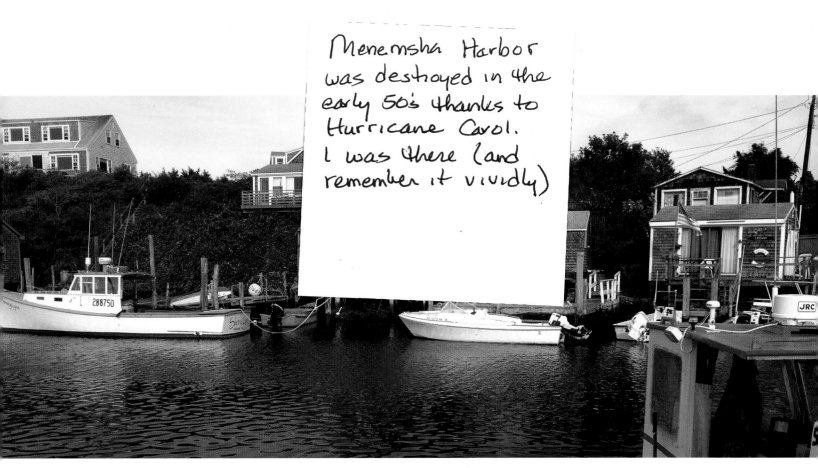

Menemsha Harbor was destroyed in the early 50's thanks to Hurricane Carol. I was there (and remember it vividly)

Cottages overlook a part of Menemsha Harbor with its fishing boats.

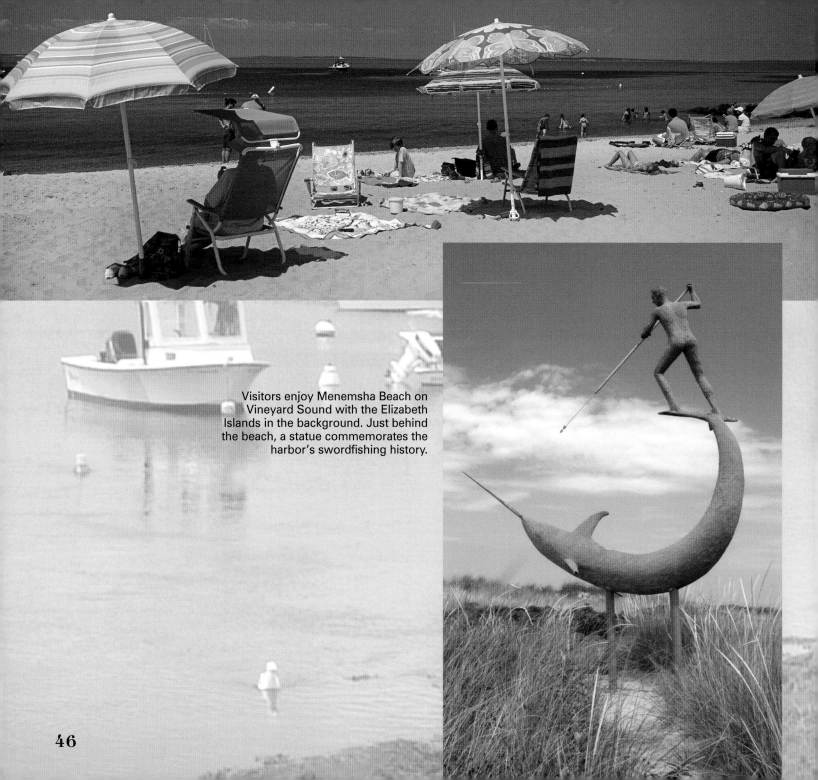

Visitors enjoy Menemsha Beach on Vineyard Sound with the Elizabeth Islands in the background. Just behind the beach, a statue commemorates the harbor's swordfishing history.

Throughout the area, there are a variety of accommodations for the visitor.

Aquinnah

Aquinnah, or Gay Head, as it was formerly known, is the smallest town on the Island in both population (about 200 year round) and size (four square miles). This most western end of land is the site of two noteworthy features: one natural, the cliffs of clay first described by Bartholomew Gosnold in 1602, and the other man-made, the Gay Head Lighthouse, built more recently in 1799. Recognized as a tribe in 1987, the Native American Wampanoags are involved in many of the town's activities.

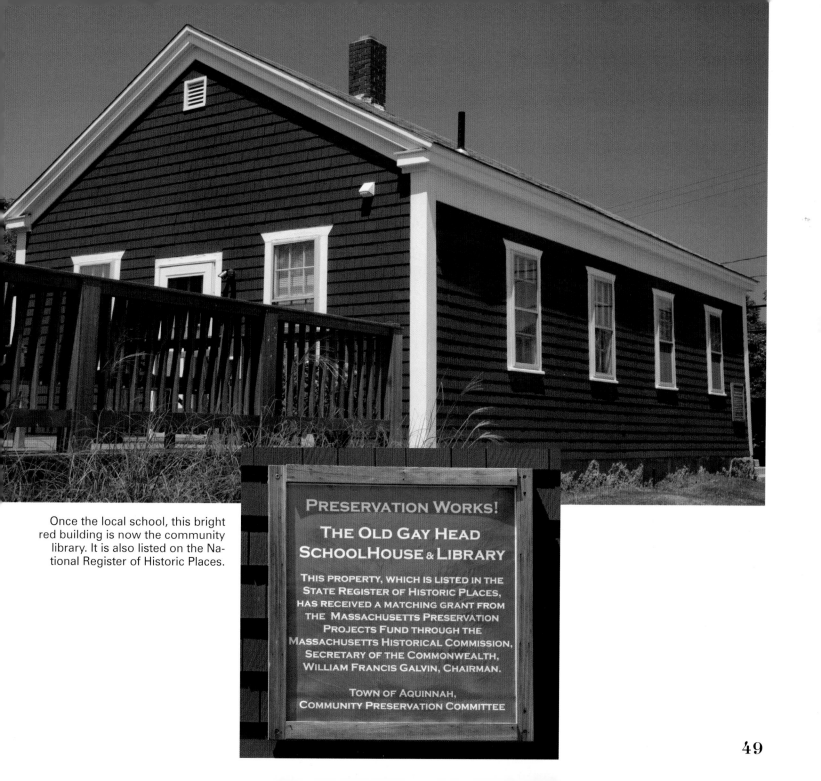

Once the local school, this bright red building is now the community library. It is also listed on the National Register of Historic Places.

PRESERVATION WORKS!

THE OLD GAY HEAD
SCHOOLHOUSE & LIBRARY

THIS PROPERTY, WHICH IS LISTED IN THE
STATE REGISTER OF HISTORIC PLACES,
HAS RECEIVED A MATCHING GRANT FROM
THE MASSACHUSETTS PRESERVATION
PROJECTS FUND THROUGH THE
MASSACHUSETTS HISTORICAL COMMISSION,
SECRETARY OF THE COMMONWEALTH,
WILLIAM FRANCIS GALVIN, CHAIRMAN.

TOWN OF AQUINNAH,
COMMUNITY PRESERVATION COMMITTEE

Years ago, when livestock would wander away from home, they would be captured and placed in the local pound. Owners could then retrieve the animals.

Shops and galleries are found near the lighthouse.

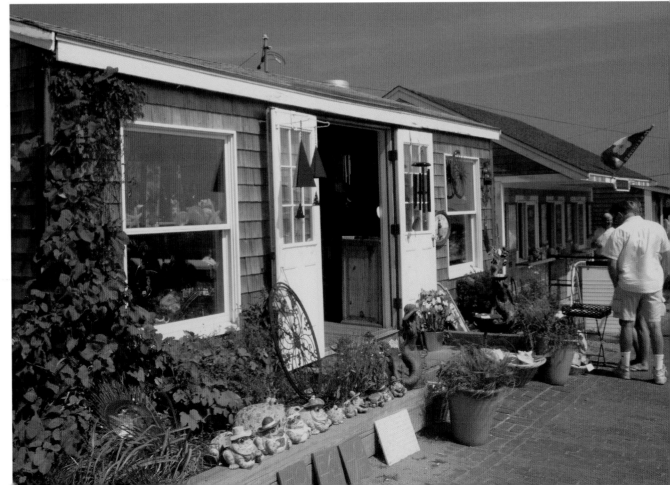

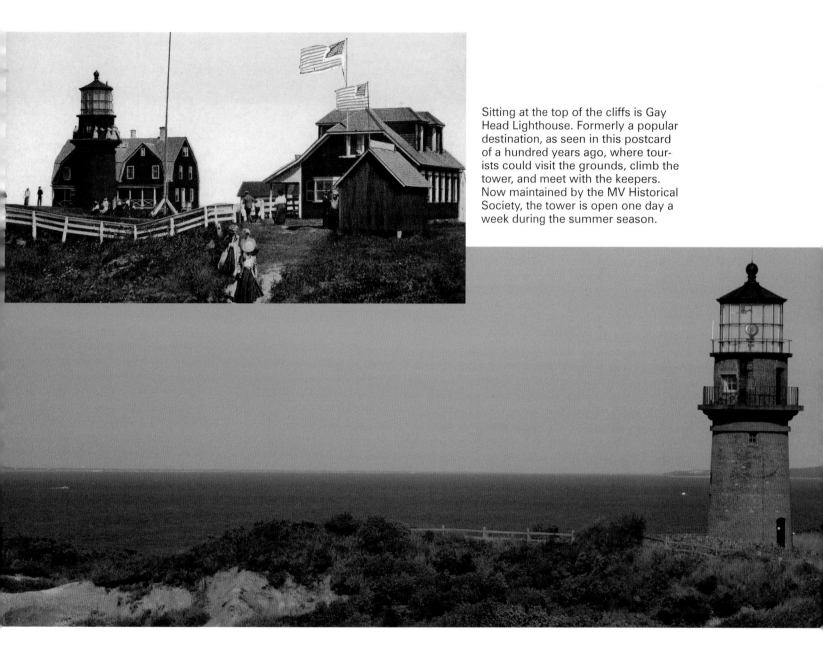

Sitting at the top of the cliffs is Gay Head Lighthouse. Formerly a popular destination, as seen in this postcard of a hundred years ago, where tourists could visit the grounds, climb the tower, and meet with the keepers. Now maintained by the MV Historical Society, the tower is open one day a week during the summer season.

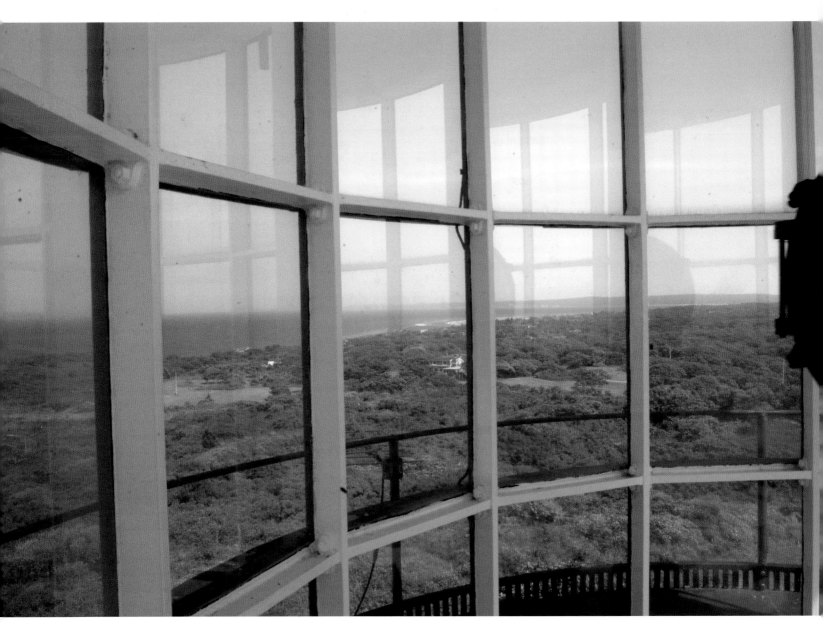

Looking northwest and inside the light room, the red beam flashes out to Vineyard Sound.

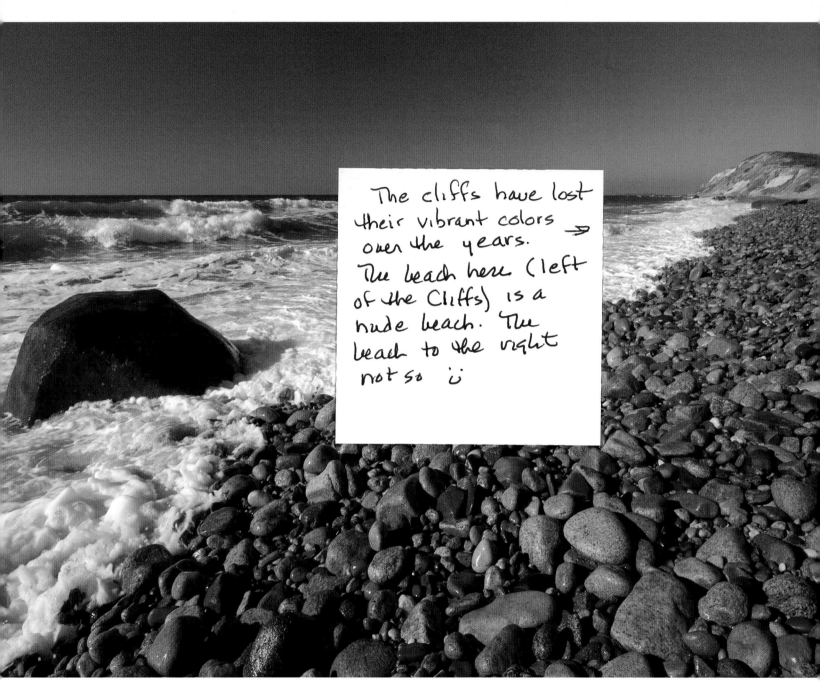

The cliffs have lost their vibrant colors over the years. ⇒
The beach here (left of the Cliffs) is a nude beach. The beach to the right not so ☺

A rocky beach with the Gay Head cliffs in the distance.

Edgartown

Originally known as Great Harbor, Edgartown, in 1642, was the first English settlement on the island. When one travels to Edgartown, located at the eastern end of the island, they are said to be going "down island." A reminder of the islands maritime past, when a ship was sailing east it was said that they were sailing "down east" because the longitude was decreasing. With the development of the whaling industry in the 1800s, Edgartown was one of the major ports, and although the clipper ships and whalers may be gone, the magnificent mansions and grand churches remain. Wander the side streets and find outstanding architectural styles reminiscent of previous generations. Now a tourist destination, the town features up-scale restaurants and galleries. More than any other town on the island, Edgartown boasts of numerous and varied attractions. Just across the harbor is Chappaquiddick Island and Cape Poge Wildlife Refuge.

 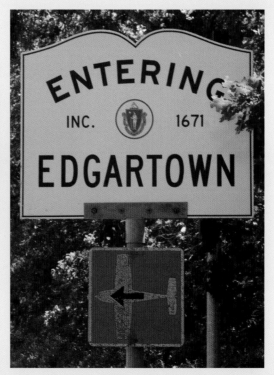

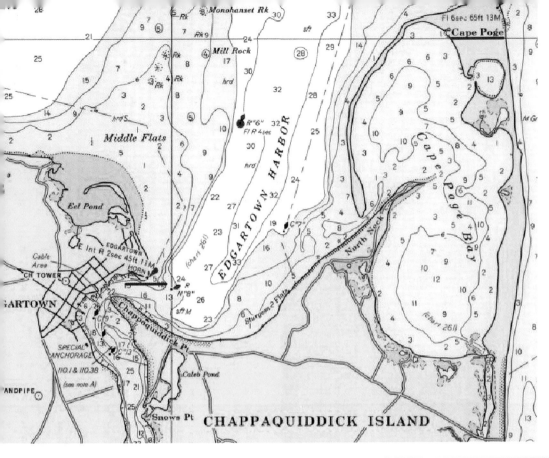

Once a whaling center, this navigational chart shows Edgartown Harbor, Chappaquiddick Island, and, underlined in red, the location of the two lighthouses.

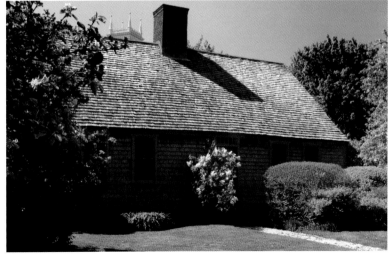

Now a museum, the William Vincent House was built in 1672 on nearby Great Pond and is the oldest house on the island. It was later moved to this location on Church Street. The house is maintained by the MV Preservation Trust and is open for tours during the summer season.

David loved to go to Cannonball park. The one time he's been to the Vineyard since Quinny was born included a trip to the park (with Quinny) ↓

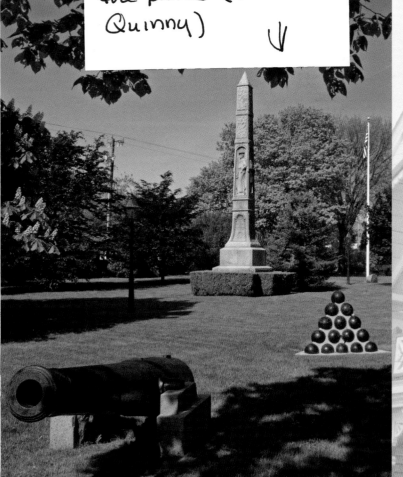

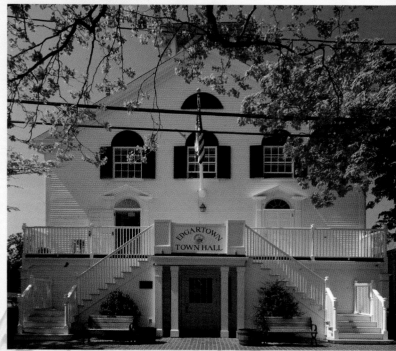

The distinctive Edgartown Town Hall is located on Main Street.

Memorial Park, more commonly referred to as Cannonball Park, was dedicated on July 4th, 1901, to the seventy Vineyard soldiers who died in the Civil War.

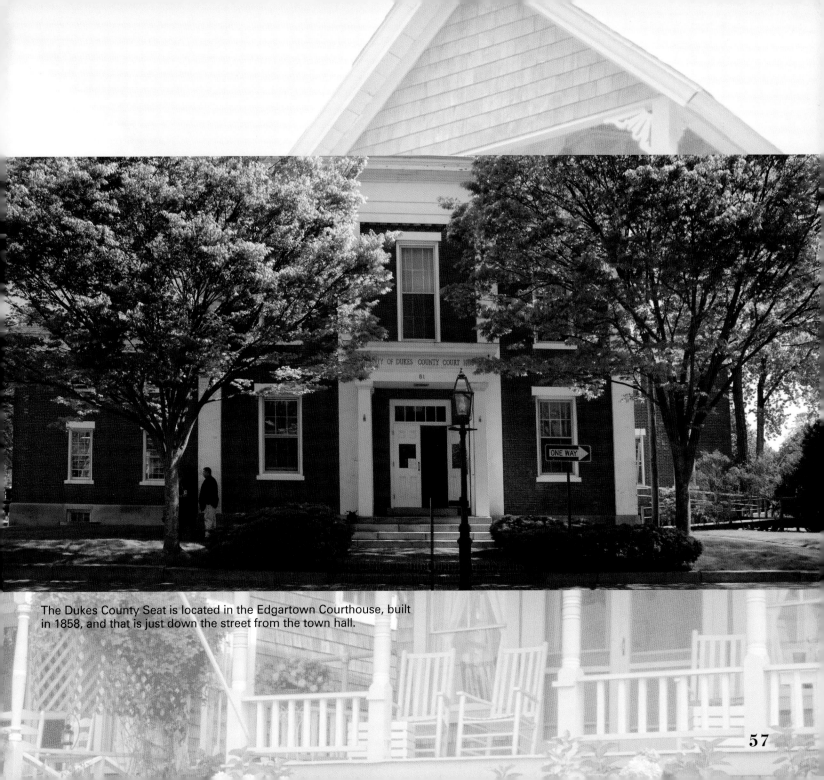

The Dukes County Seat is located in the Edgartown Courthouse, built in 1858, and that is just down the street from the town hall.

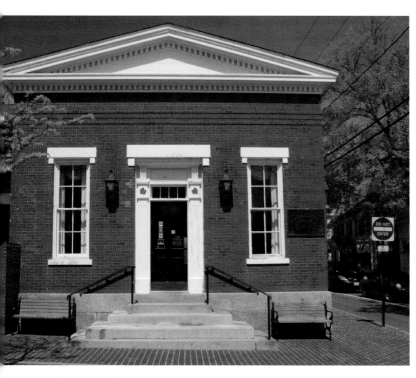

The Bank of Edgartown is built in the
Greek revival architectural style.

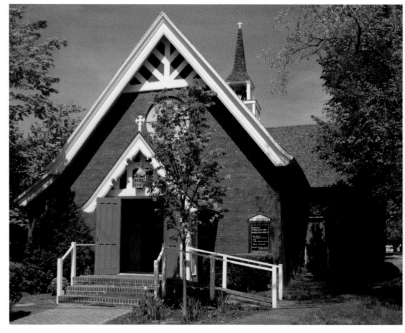

The brick St. Andrew's Episcopal Church
is located on a quiet side street.

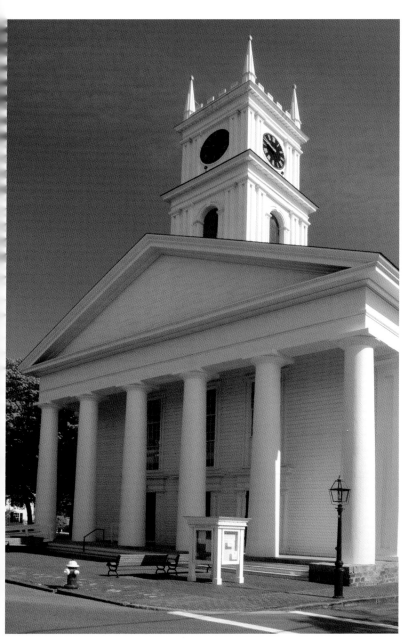

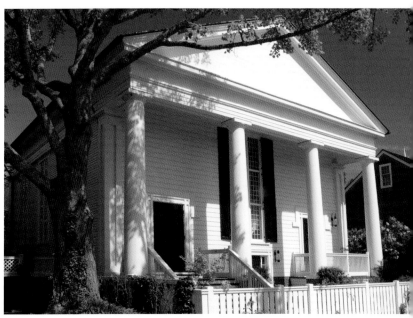

Walk the streets of Edgartown and you will find large, distinctive churches.

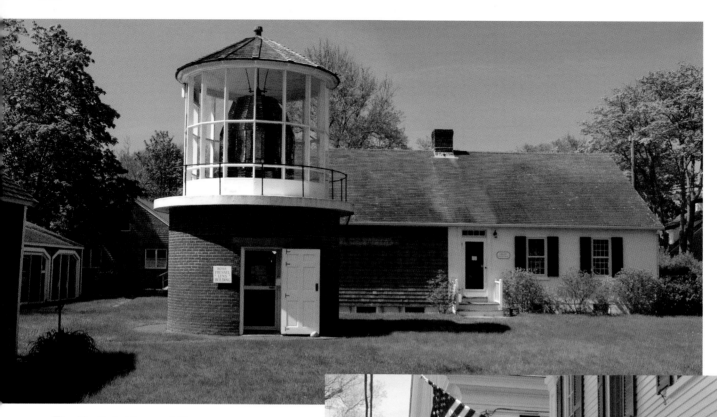

The Martha's Vineyard Museum, located on School Street, with several houses and galleries, exhibits a variety of historical material. The original Fresnel lens from Gay Head Light is housed in this shortened tower.

Along many streets, former "sea captains" homes have been converted to luxurious B&B's.

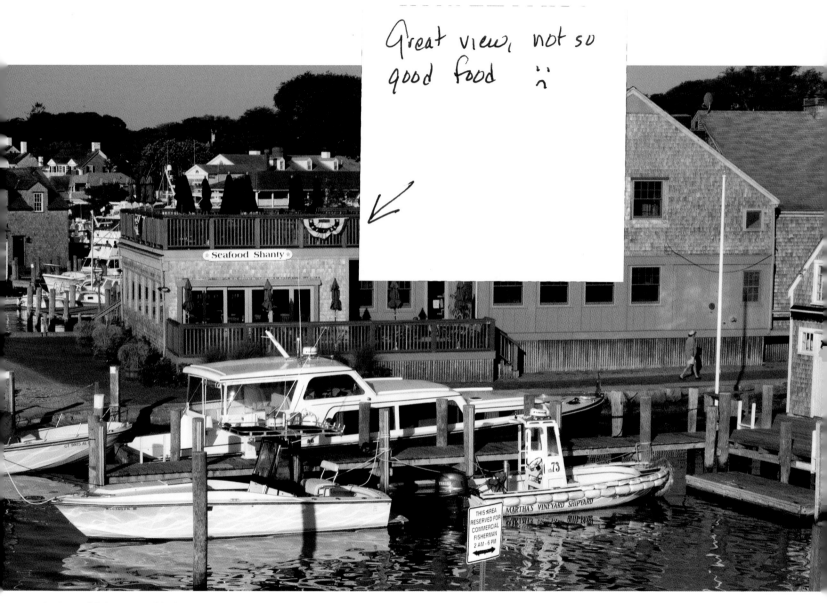

A view of Edgartown Harbor.

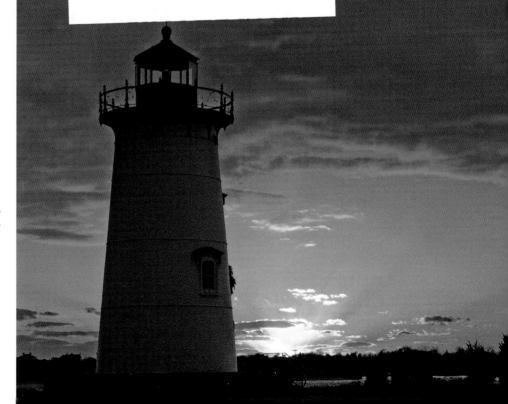

The Vineyard has 5 light houses... Edgartown is by far my favorite

Decorated with a wreath for the holidays,
Edgartown Light at sunset.

find

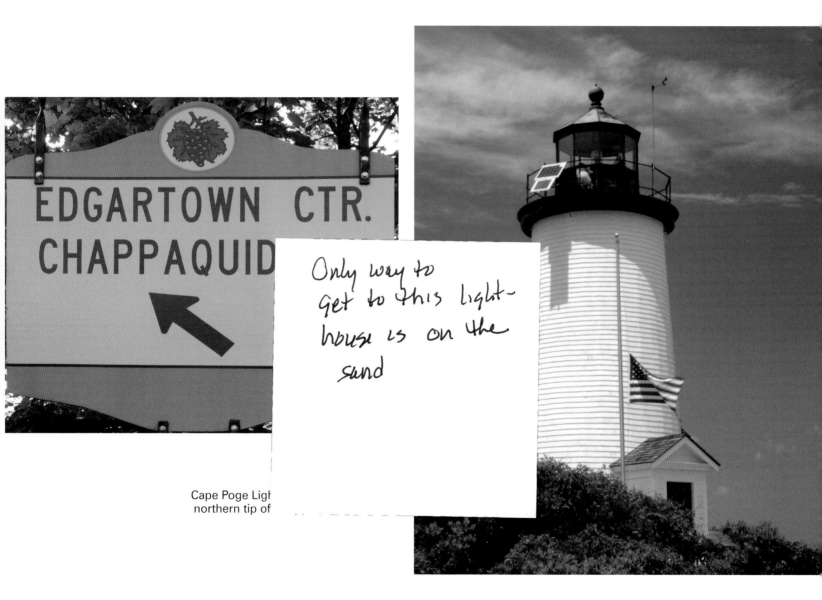

EDGARTOWN CTR.
CHAPPAQUID

Cape Poge Ligh
northern tip of

Only way to
Get to this light-
house is on the
sand

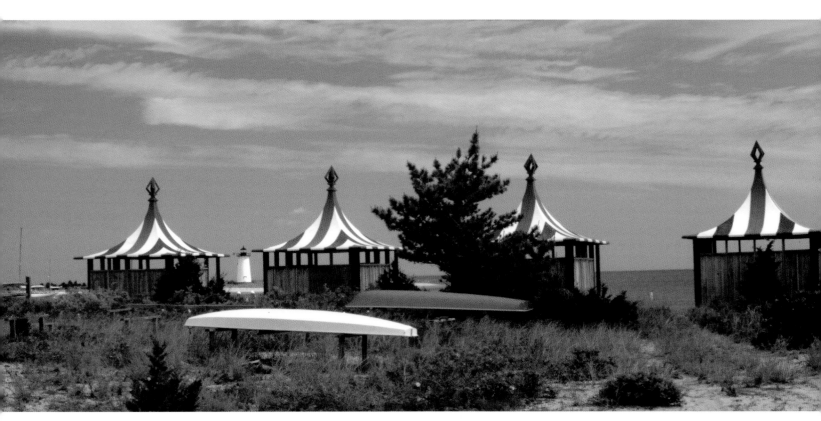

Brightly colored cabanas at a Chappaquiddick Beach Club.

Oak Bluffs

While Edgartown is primarily an outcome of the whaling industry, Oak Bluffs, originally part of Edgartown and known earlier as Cottage City, traces its historic roots back a century and a half to the spiritualist camp meetings. In the mid-1800s, revival meetings would be held with congregations from off-island living in tents for a week or two. Through the years, more permanent structures were built and the Martha's Vineyard Campmeeting Association now has more than 350 Gingerbread cottages. Oak Bluffs is a paradox, with the staid and proper Campground offering quiet and reflective living on the one hand, and a town that is "wet" (as is Edgartown) has bars, restaurants, and a variety of shops that add to both an active day and nighttime lifestyle on the other. During the summer season, the harbor is busy with ferries and visiting recreational boats. If it's activity that you want, Oak Bluffs will probably offer it.

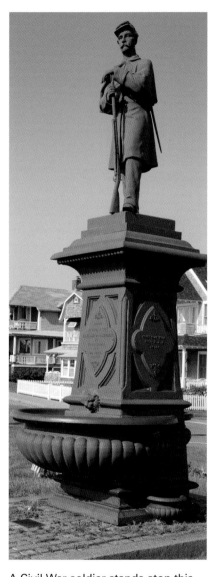

A Civil War soldier stands atop this monument, which reads "Erected in honor of the Grand Army of the Republic by Charles Strahan, Co B 21 Virginia Reg".

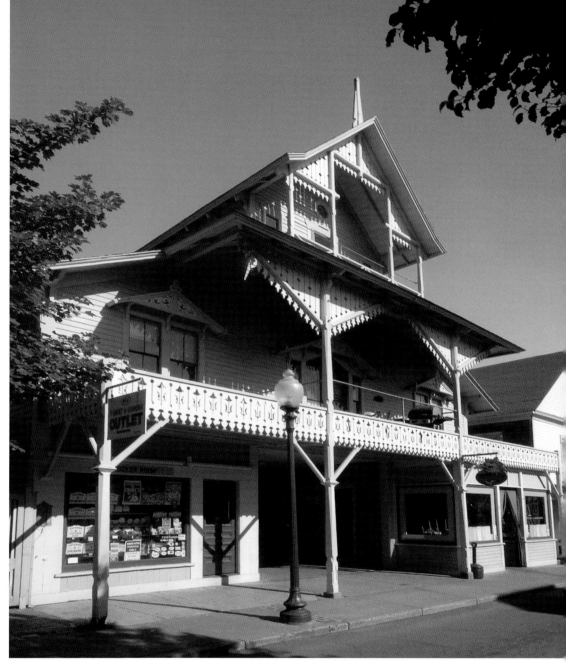

The Arcade, located on Circuit Avenue and designed by Samuel Pratt, once housed the offices and post office of the Campmeeting Association.

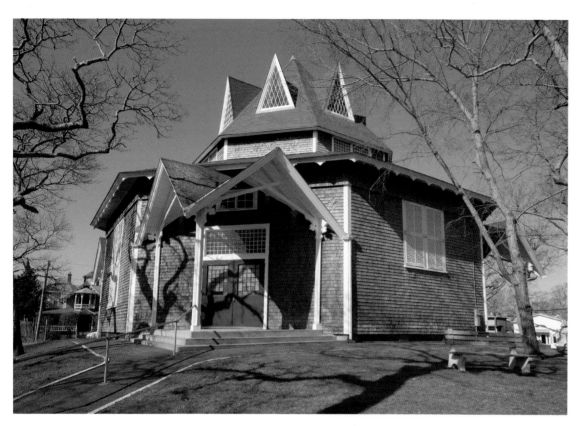

Also designed by Samuel Pratt, the octagonal Union Chapel was built as a non-sectarian house of worship. Now it is used not only for services but also for weddings, concerts, and recitals.

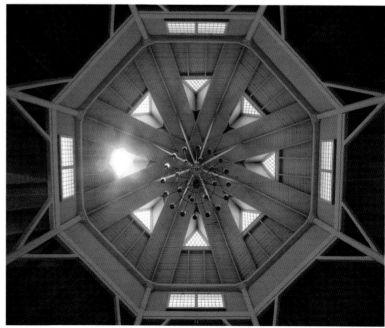

67

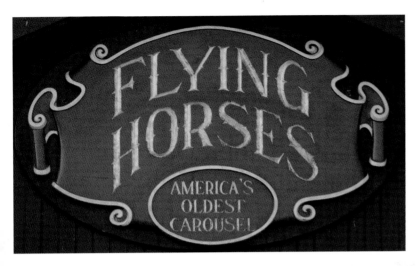

A must for every child + 'some' adults :)

⟵

The Flying Horses Carousel is the oldest operating carousel in America. Originally built in 1876 and operated on Coney Island, it was moved to Oak Bluffs in 1884. The manes and tails of the horses are made of authentic horsehair. Along with a game room, it is open during the summer tourist season.

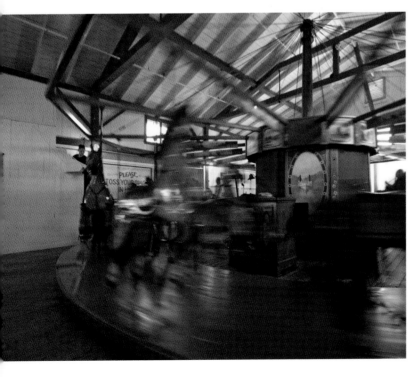

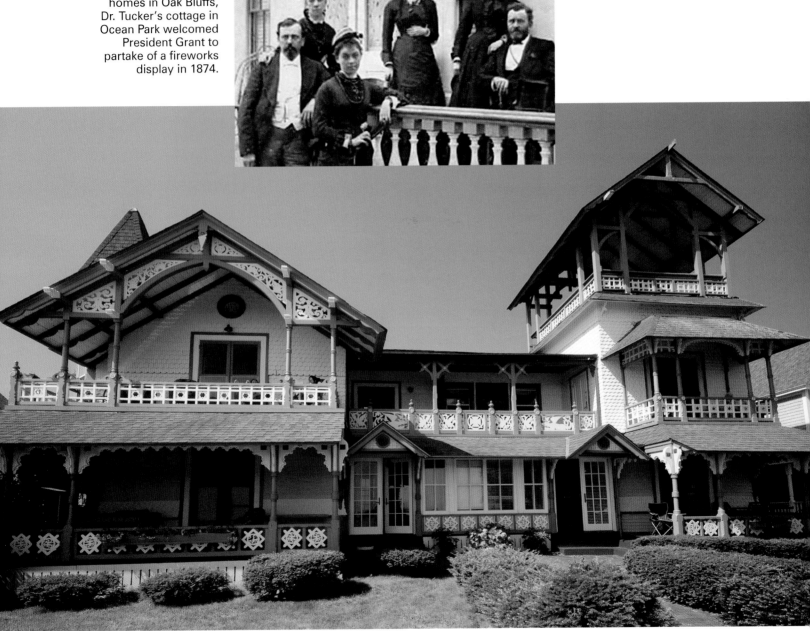

One of the larger homes in Oak Bluffs, Dr. Tucker's cottage in Ocean Park welcomed President Grant to partake of a fireworks display in 1874.

Cottages on Lake Avenue, decorated with lanterns for the annual Illumination Night celebration, face Oak Bluffs Harbor across the street.

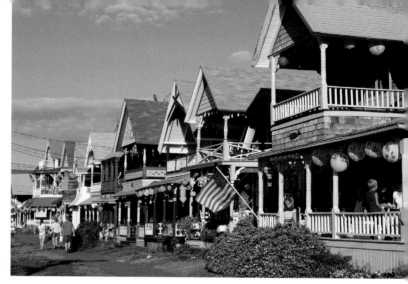

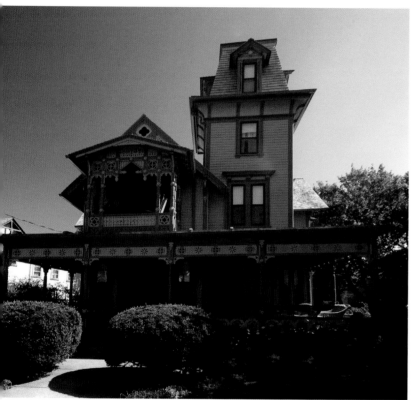

Cinderella Cottage is another lavish summer house built more than one hundred years ago. The present owner has spared no expense in a total restoration.

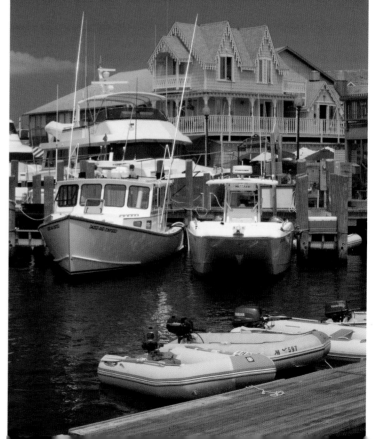

Man-made, Oak Bluffs Harbor has a variety of watercraft.

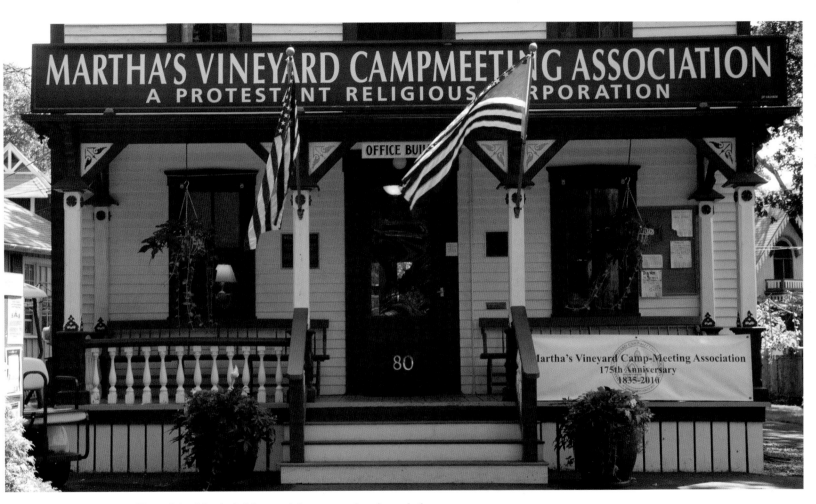

The present day office of the Martha's Vineyard Campmeeting Association.
There are more than three hundred and fifty cottages in the Campground.

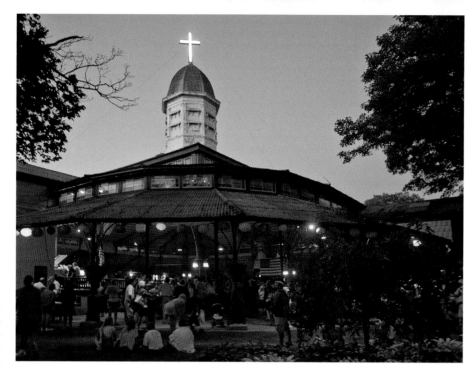

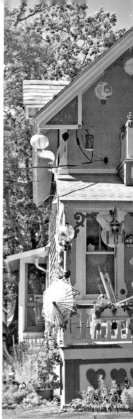

Decorated for Illumination Night, the Tabernacle is the focal point of the Campground. Graduations, lectures, Sunday services, and recitals are just some of the events that occur here. A postcard, over a hundred years old, shows the Tabernacle that was built in 1874. It is the largest wrought-iron building in the United States.

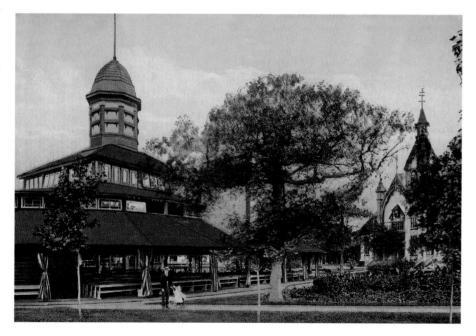

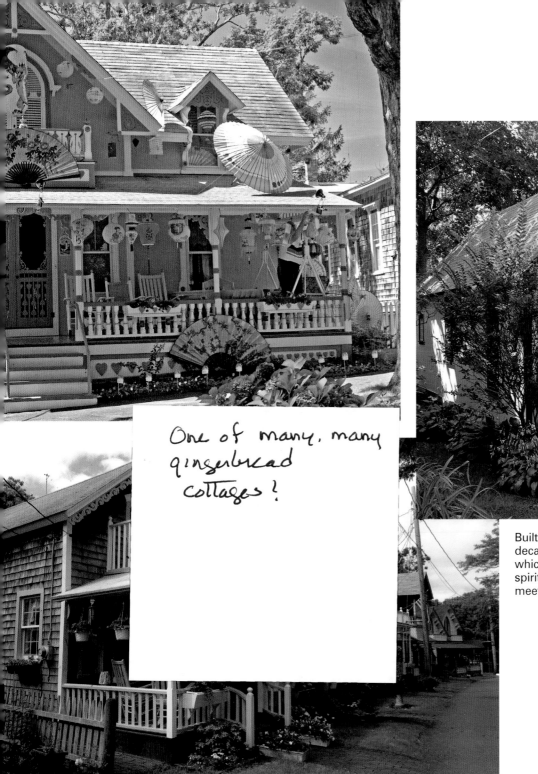

One of many, many gingerbread cottages!

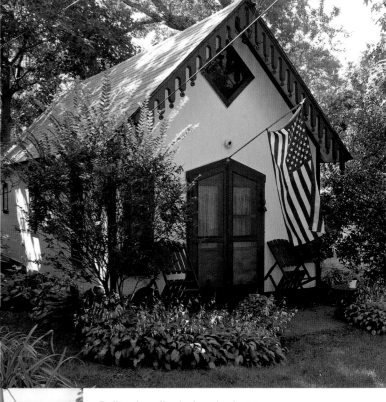

Built primarily during the last two decades of the 1800s, these cottages, which replaced tents, were used by spiritual revivalists at their summer meetings.

Organized into parks and circles, the quaint dwellings are now
summer residences for the owners. About one in six is winterized.

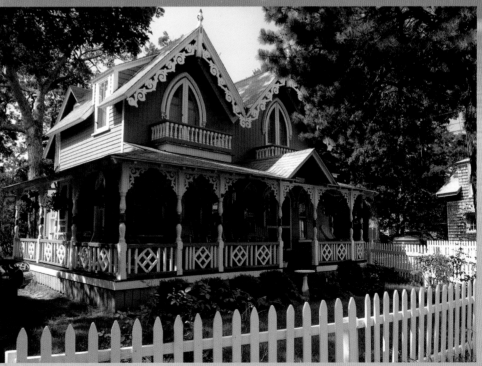

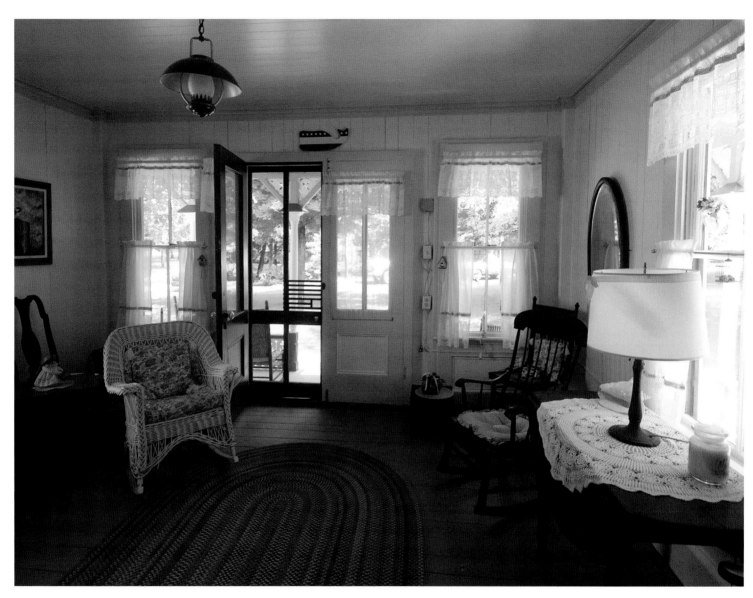

A view of a typical living room; the second floor bedroom is part of the display at the Cottage Museum.

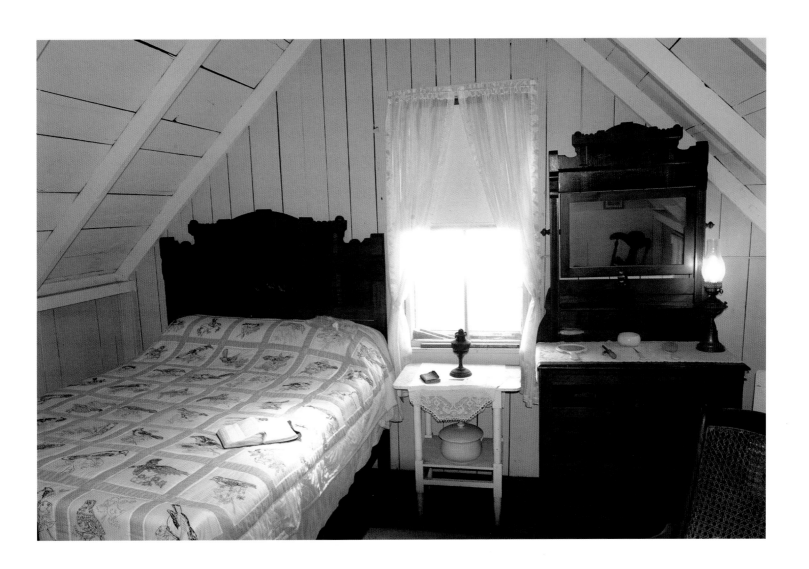

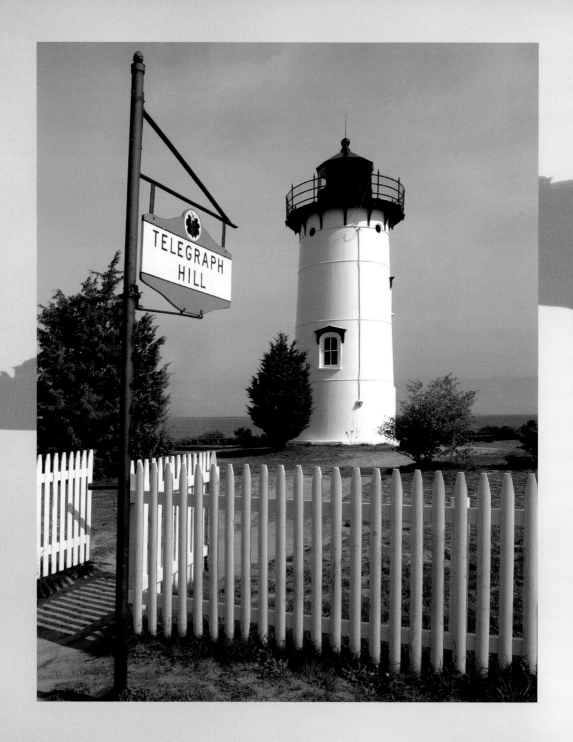

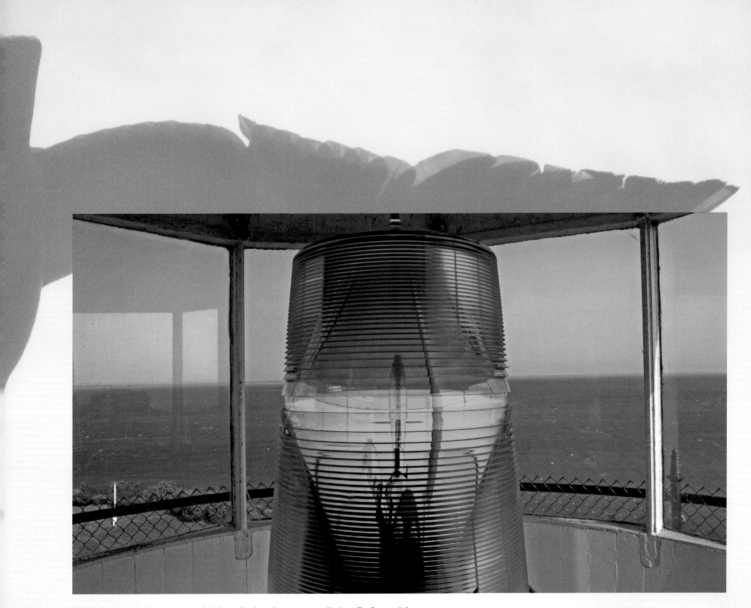

East Chop Lighthouse with its distinctive green light. Before this present lighthouse was built in 1878, signaling devices were located on the hill, advising owners of ships passing through Vineyard Sound.

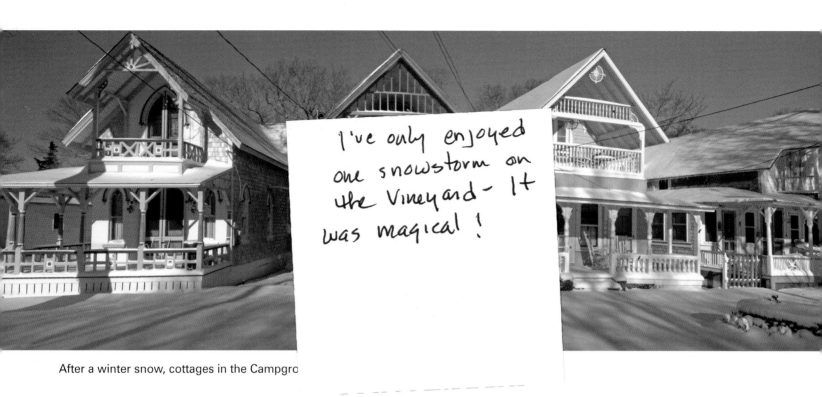

I've only enjoyed one snowstorm on the Vineyard— It was magical!

After a winter snow, cottages in the Campgr[o...]

About the Author

Arthur P. Richmond is a retired science educator who has been involved in photography for more than 50 years. He has published eleven books and his images are shown at several galleries on Cape Cod.